PILE

Petals from St Klaed's Computer

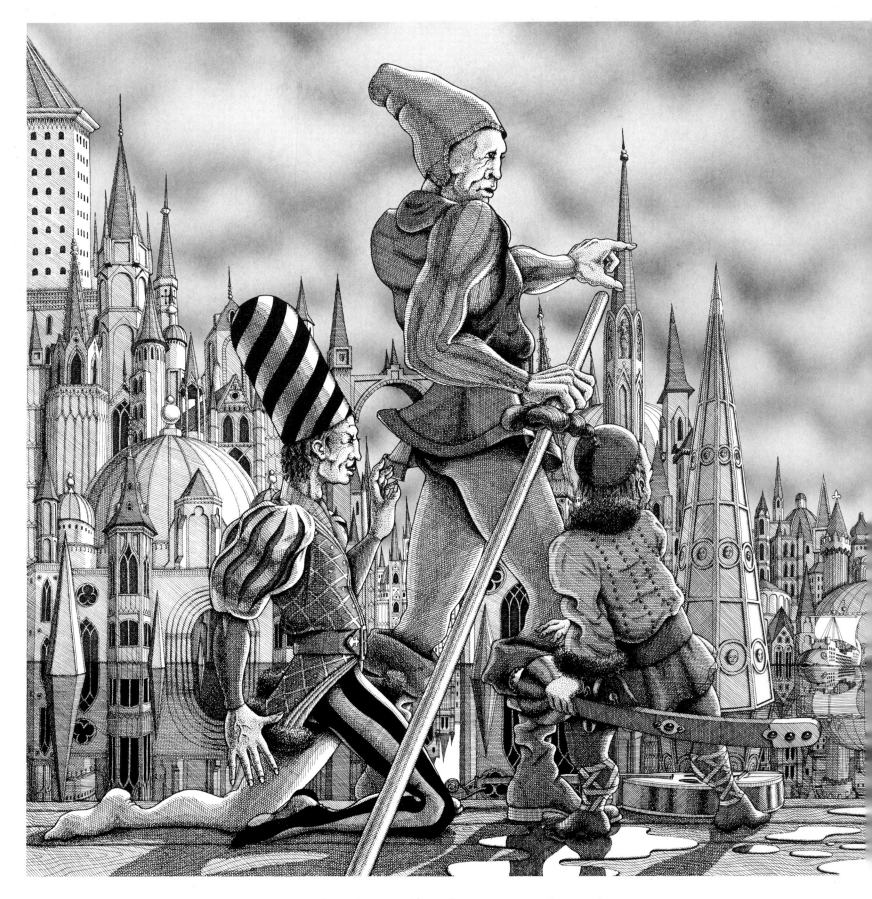

Reader, observe these three men on their raft,
Drifting in fabled time and place.
One is the hero of our art,
Prince Scart, who played a better part
And won himself at last a state of grace,
His tale transported by our craft.

BRIAN W. ALDISS

PILE

Petals from St Klaed's Computer

Illustrations by

Mike Wilks

Holt, Rinehart and Winston
New York

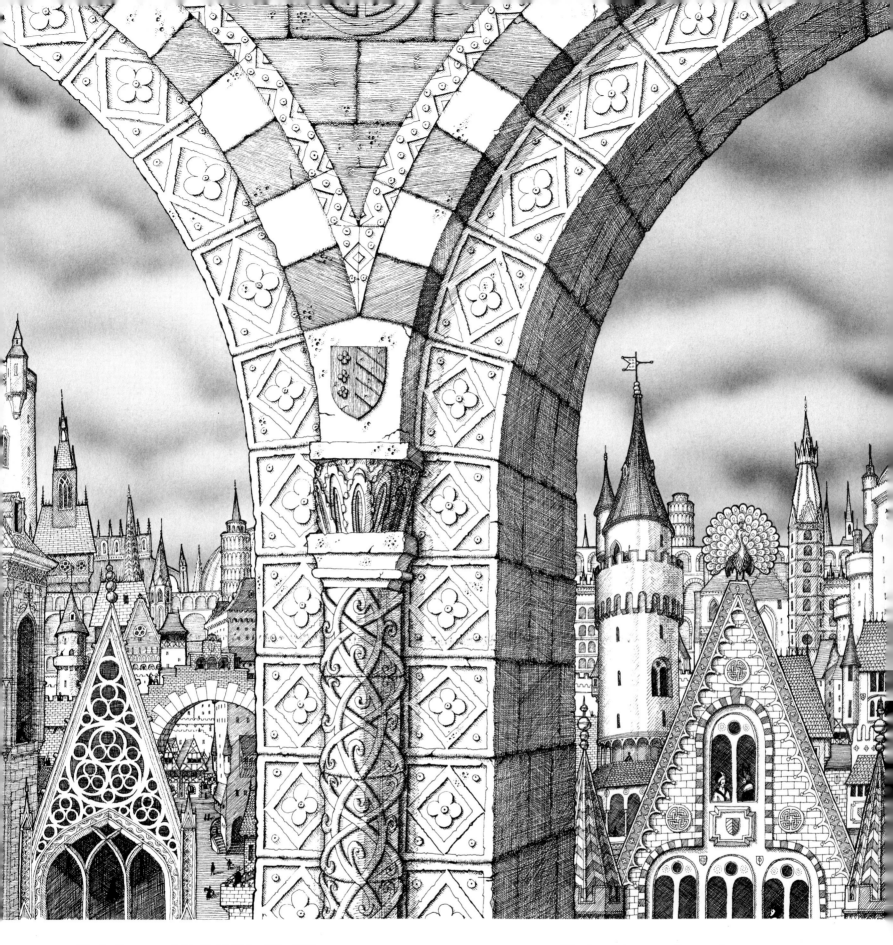

First Published in the United States by Holt, Rinehart
and Winston, 383 Madison Ave., New York, N.Y. 10017.

Published simultaneously in Canada by Holt, Rinehart
and Winston of Canada, Limited.

Library of Congress Cataloging in Publication Data

ISBN
First American Edition
Printed in Great Britain

Undecaying, undecayed,
Behold! — Pile is displayed,
All one enormous folly,
Chiselled out in fine brocade
Of stone, brick, mortar. Planned
For splendour, huge, unjolly,
Pile got out of hand.
Many merchants, solemn, skilled,
Worked, but scale and size
Began to metagrobolise
Even its founder-build-
Ers; its complexity conquers land and sea,
Its marble mortuary conscientiously
Overturns geography, outlasts geology,
Outblasts psychology —

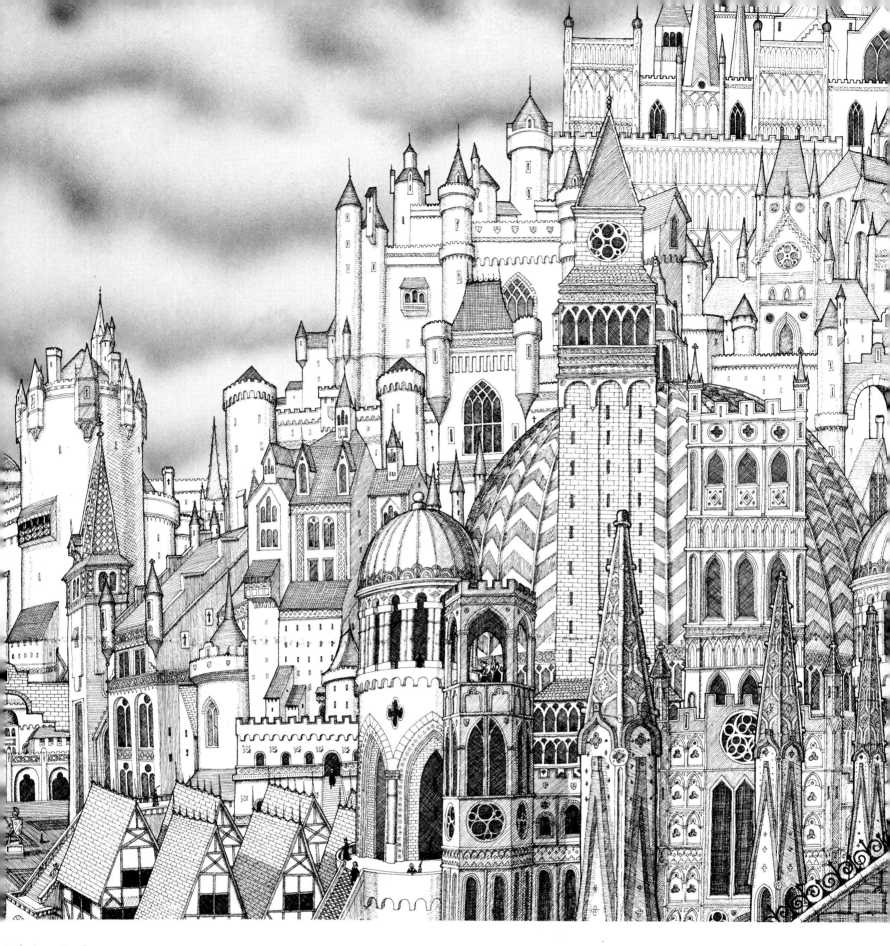

And
Makes labyrinthine home
For a select band
Of men — if you can say home
And not call it an
Agate, metropolitan,
Metronome.

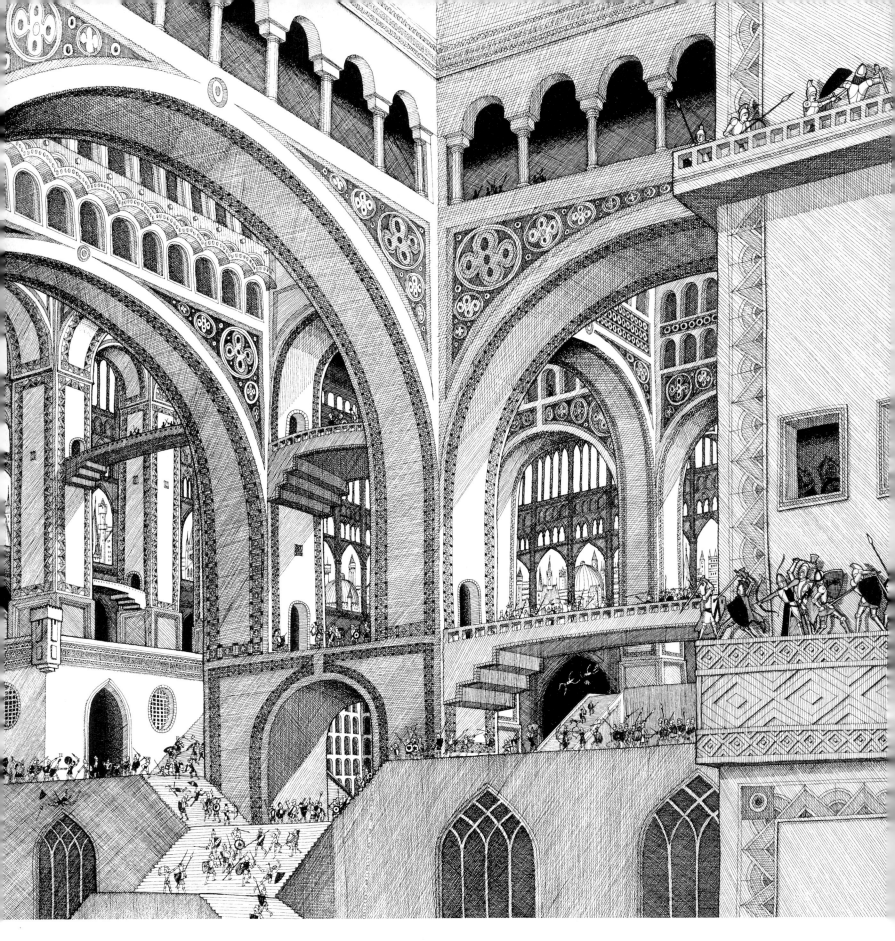

In this many-splendoured mausoleum,
Where even space becomes mosaic,
Every angle algebraic,
Pileish princes fight each other —
Cousin with cousin, brother with brother —
Their lands one set of chambers or another ...
Oh, you should see 'em,
Warring in a way archaic,
Spilling blood and strewing brains
All about their great museum —

Yet always mopping up the stains
Each evening elegaic.

But for this, peace reigns.

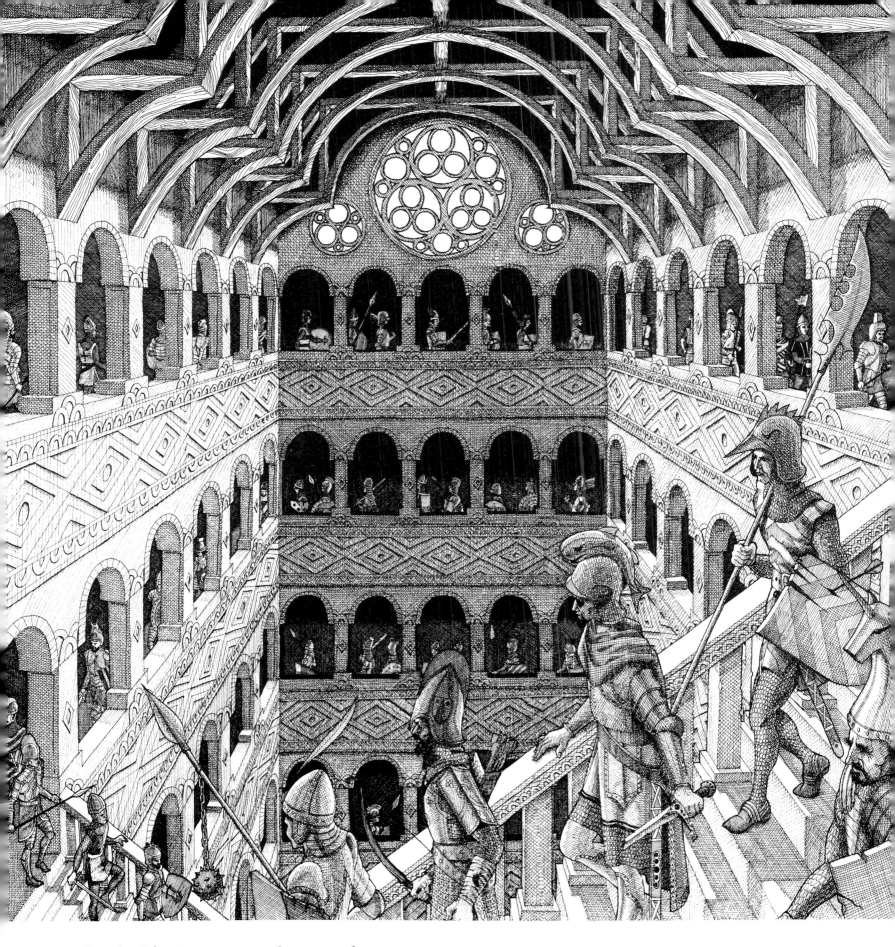

Within the Pile, Dame Nature plies no trades.
Within the mighty Pile there are no groves or glades
Where zephyrs whisper sweetly. So the droves of blades,
The warlike troves of armour, ring along arcades
And staircases and halls. The ambuscades
Of swordplay find no peace till echo fades
With daylight's dying down the dull parades.

Then tortured spirits flee among the shades
Or linger ruined till the morrow's raids.

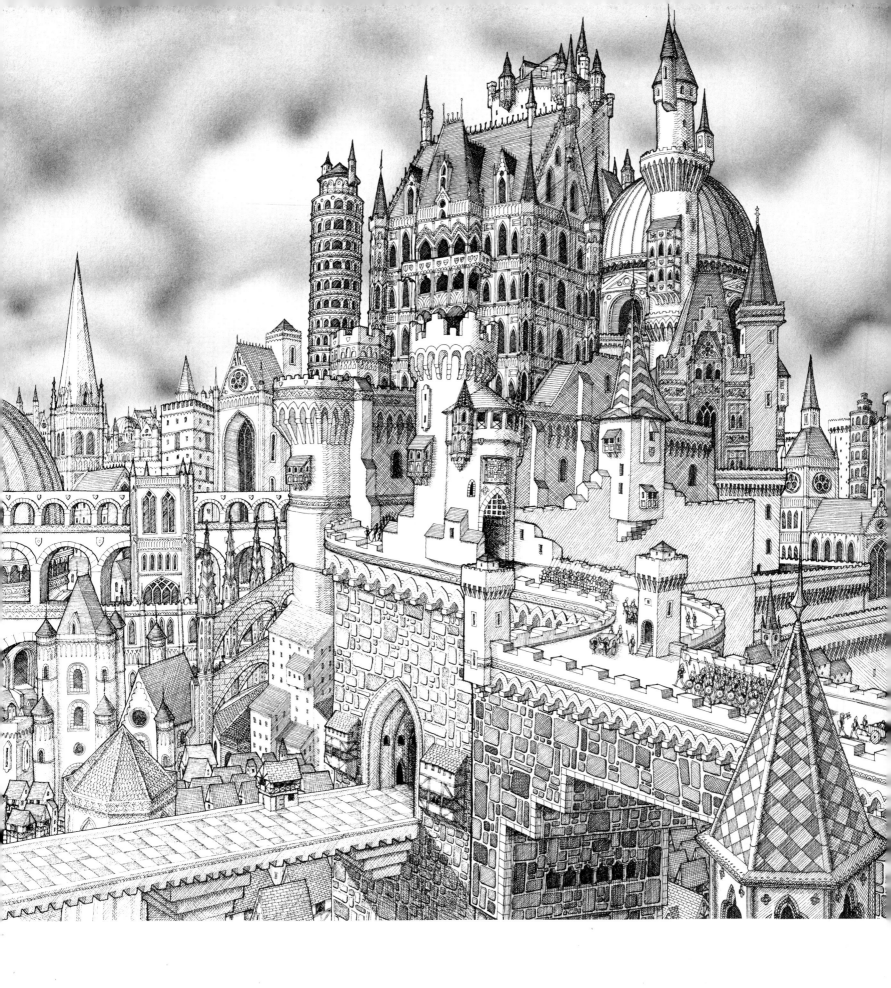

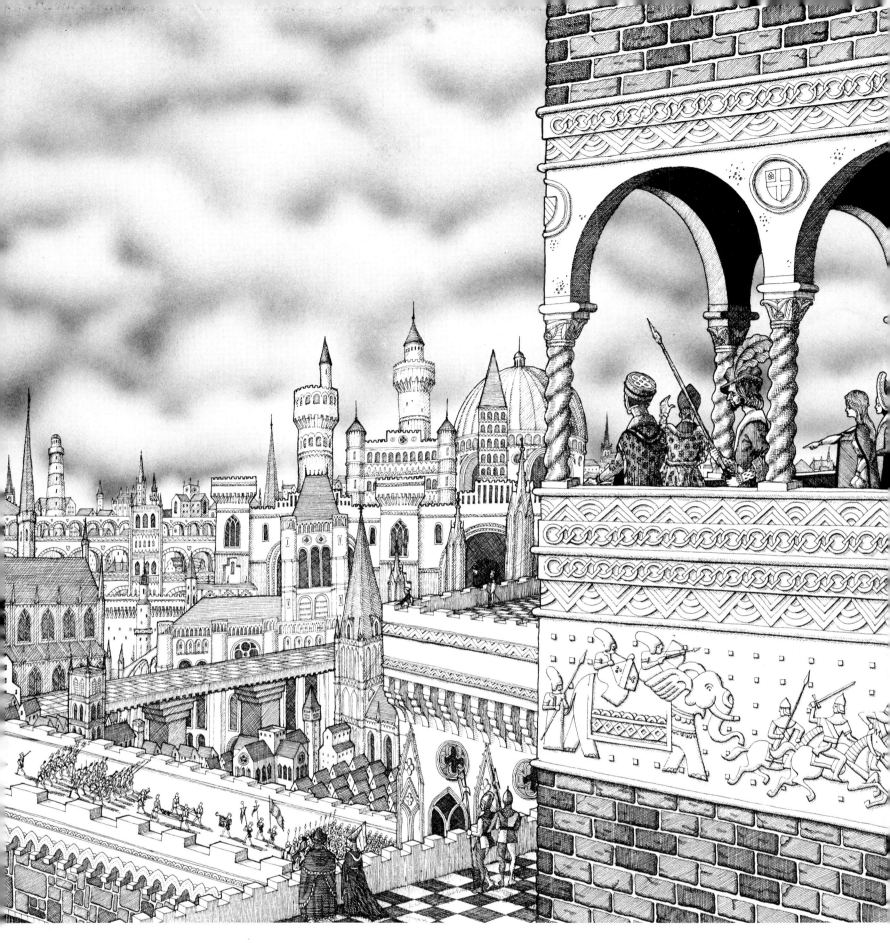

Dreamers whose gaudy plans miscarried,
Schemers whose tawdry lands were harried,
Men who remained for life unmarried,
Moralists meek (with some rather scary ones), police
 officers, fiddlers, philosophers sly,
Octogenarians, grey vegetarians, astronomers with a
 cast in one eye,
Antiquarians, bald ones and hairy ones, scientists,
 prelates, and medics of note,
Mathematicians and monks with positions, physicians.
 and fellows and learners by rote,
Alchemists who turned their coat,
Architects that valued style high,
Masons mounting stone a mile high,
All these helped to build the Pile high,

Helped it bloat,
Helped take Heaven by the throat.

Cold elegance,
Intolerance,
Circumstance,
All that was made
Encouraged parade.

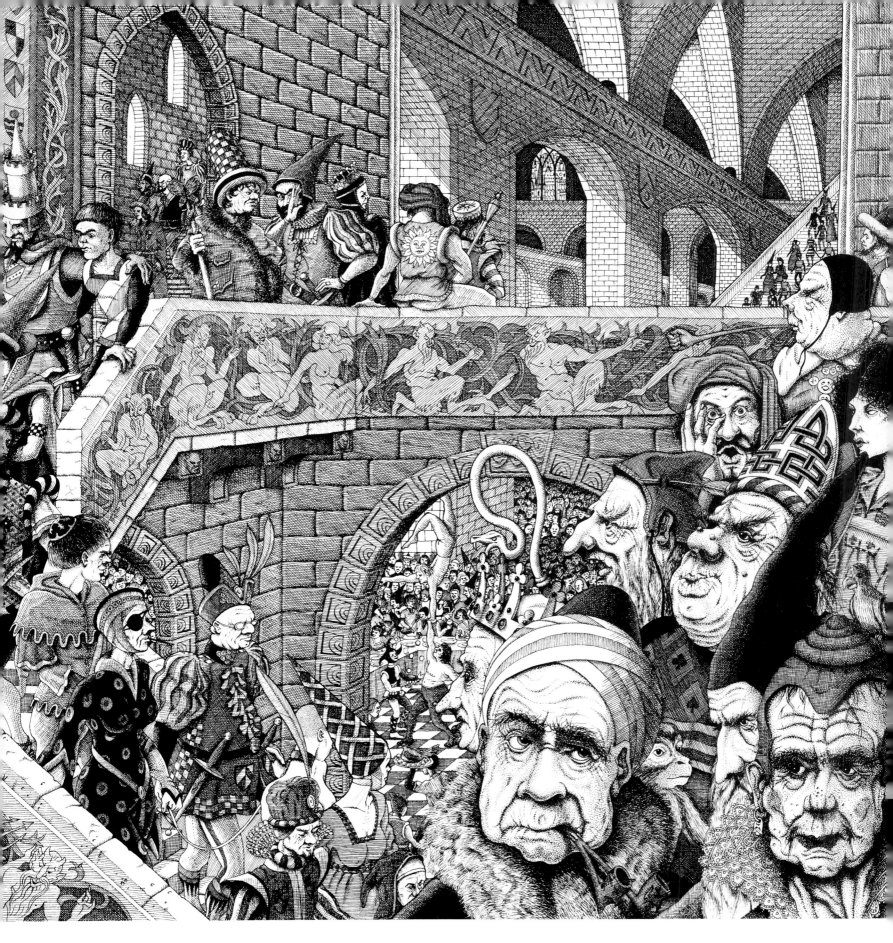

Courtiers hardly courtly,
Porters more than portly,
Dowagers, scroungers, chaps who powder,
Gluttons due for strokes quite shortly,
Rakes who treat the stately hall like stables,
Gather in a motley crowd, a
Mob, about the groaning tables,
Boozing, dining, swinking, wining,
To float the court —
Tout court, in short —
In port.

Such riff-raff may be noticed and abhorred
At the Prince Scart's o'er-loaded board.

Egged on by eager advocates,
Since childhood Scart has warred
With princely cousins. In dispute
Are certain galleries, complete
With view. Today Scart celebrates
A victory.

 Well, a defeat ...

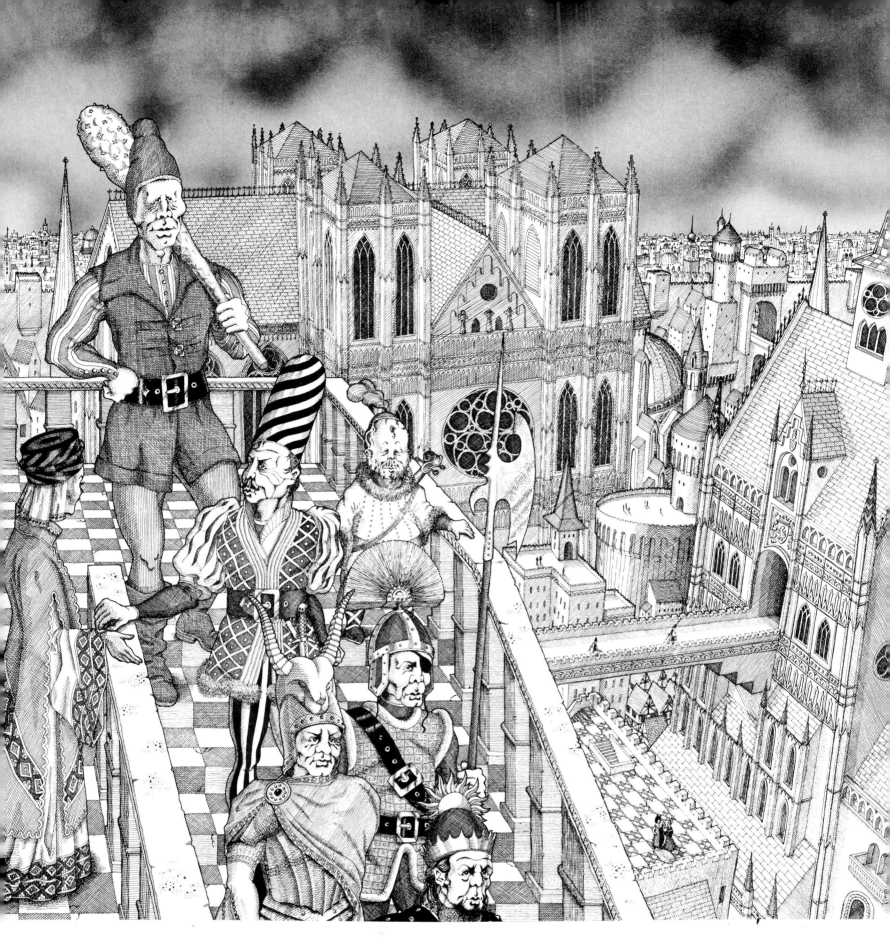

Afterwards, Prince Scart
Decides to parade himself
With friends, a chosen trinity
Given to debauchery and divinity,
Plus Dwarf and Torturer Elect —
In fact, his Minister of Treasons.

The Prince will be carried
In a palankeen, erect,
Since it is announced that he
For good dynastic reasons
Will soon be married,
Thus combining sex with sect.
Going to parade, he
Pats his chosen lady
Of ladies. (Ladies
Think Pile Hades.)

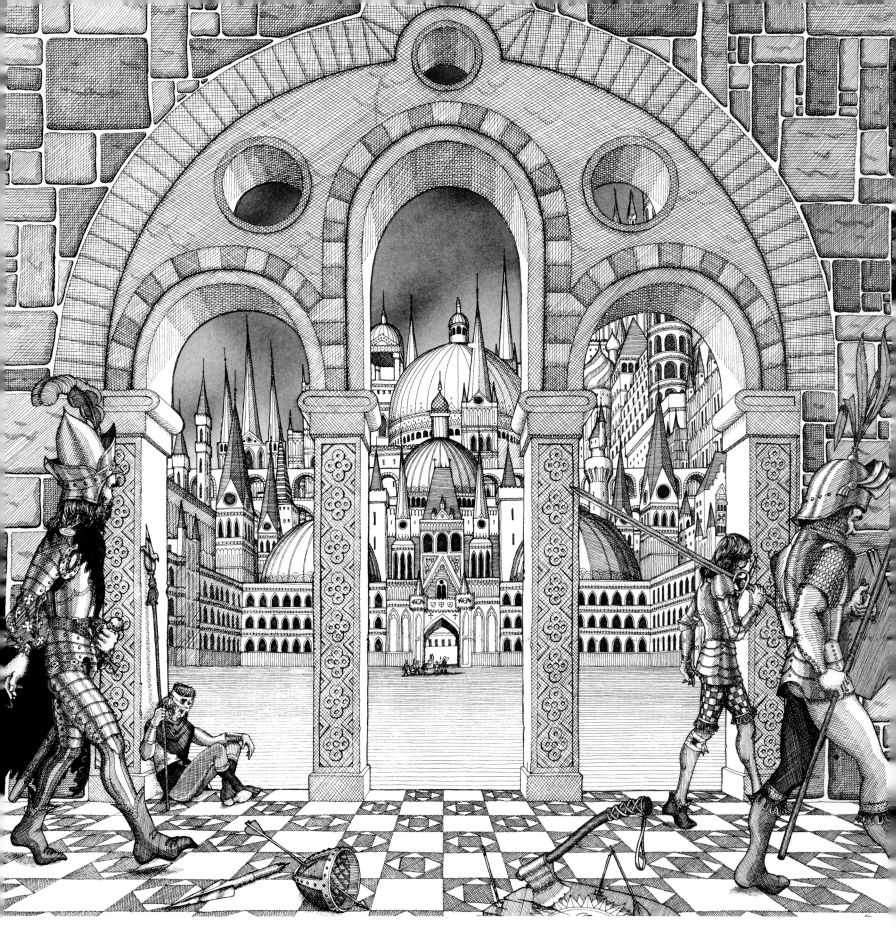

What matters just a little indigestion?
What matter matters Conscience calls in question?
What matter if the enemy is nigh,
What matters talk of other states of being?
The minarets amaze, the spires aspire,
The afternoon perspires in the sky.
Besides, Scart's found the key — so long unseen
By human eye, 'tis reckoned a romance —
Uncovering a secret route which leads
Its owner to the Oracle-Machine
That quantifies great Pile's continuance.
No wonder that he grins and feeds!

Drive on unseeing,
Drive in state,
The Great are only great by being great,
The belly's full!
Pull, helots, pull!
Look on my works, ye Mighty,
Look on and eructate!

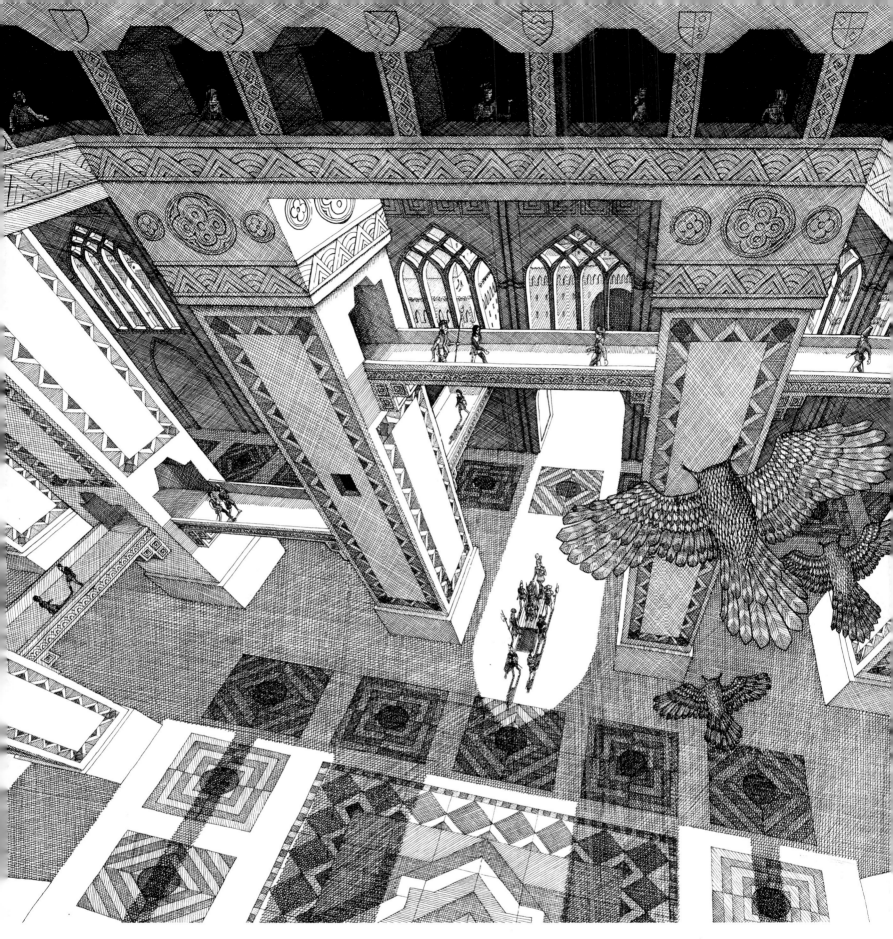

By hidden ways and secret circumbendibus,
They reach the Oracle, all tremulous.

Behind walls
In owl-sodden halls
Of phonocamptic air,
Far from where Pile's lowly great
Yawn and fawn and fornicate,
Is that tremendous crossroads where
Religion, Fate, and Science meet:
Is the Computer of St Klaed,
Is the Lord God's hearing-aid.

Mind on eternal beat —
That's that lofty thinking node
More ancient than the oldest ode,
Formed from wood and stone and pewter,
The Blessed St Klaed's Computer,
The time-defying, dust-denying, thought-supplying,
 terrifying, buttress-flying, sombre-sighing, never-
 lying, citifying,
Stupifying,
Blessed St Klaed's Computer,
Working out the Cosmic Code
In manner conscienceless and neuter.

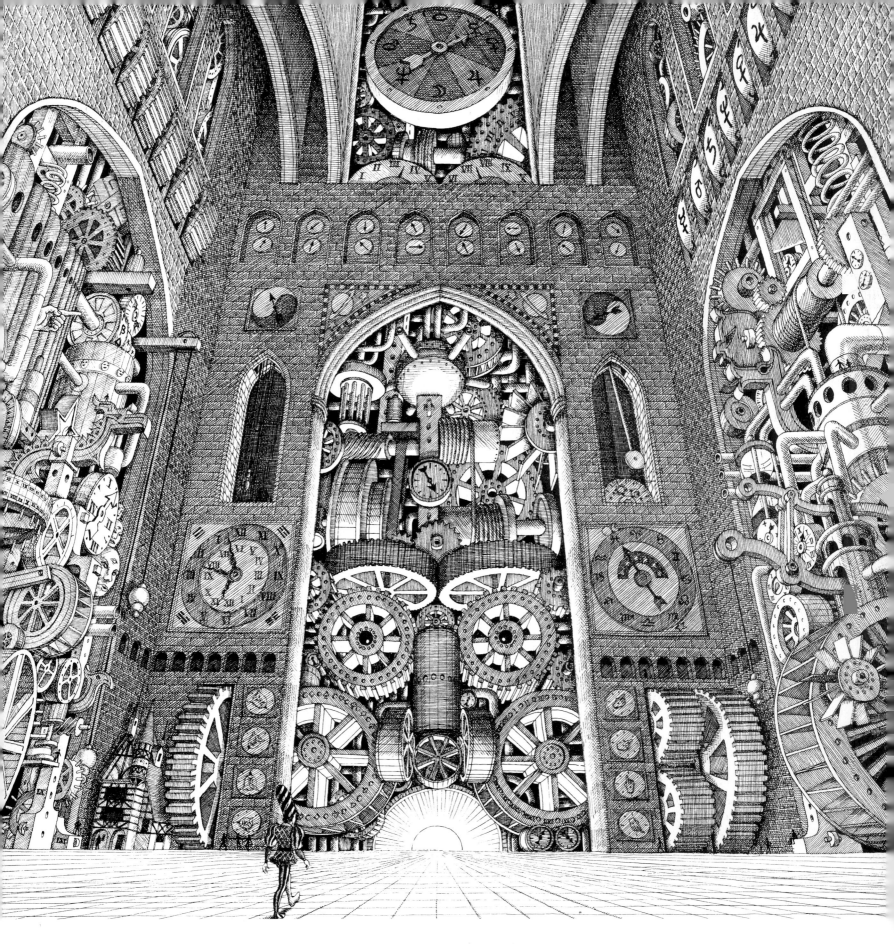

To Scart, even St Klaed is plunder;
He will have what he must seek.

Scart speaks with voice of thunder:
'O Mole in molecules of Pile,
Old Science-Syphon, One of Wonder,
Godling of guile and Whelm of While,
Great Parent of this Place unique,
Hear me, Prince Scart, and all I speak.'

A mighty Something doth unravel
From foundations, bowels, and navel
Its contemplation and replies
'Speak!' as plunging lapwing cries.

'I'm plagued,' says Scart, 'in every enterprise.
Destroy my enemies, destroy
My cousins, at whatever cost —
What's lost is lost, that's Writ —
Destroy them hip and thigh —
So make of Pile a Gobi,
So they die,
Or I'll have a phobi-
A fit.'
His word
Was heard
Then, 'So be
It.'

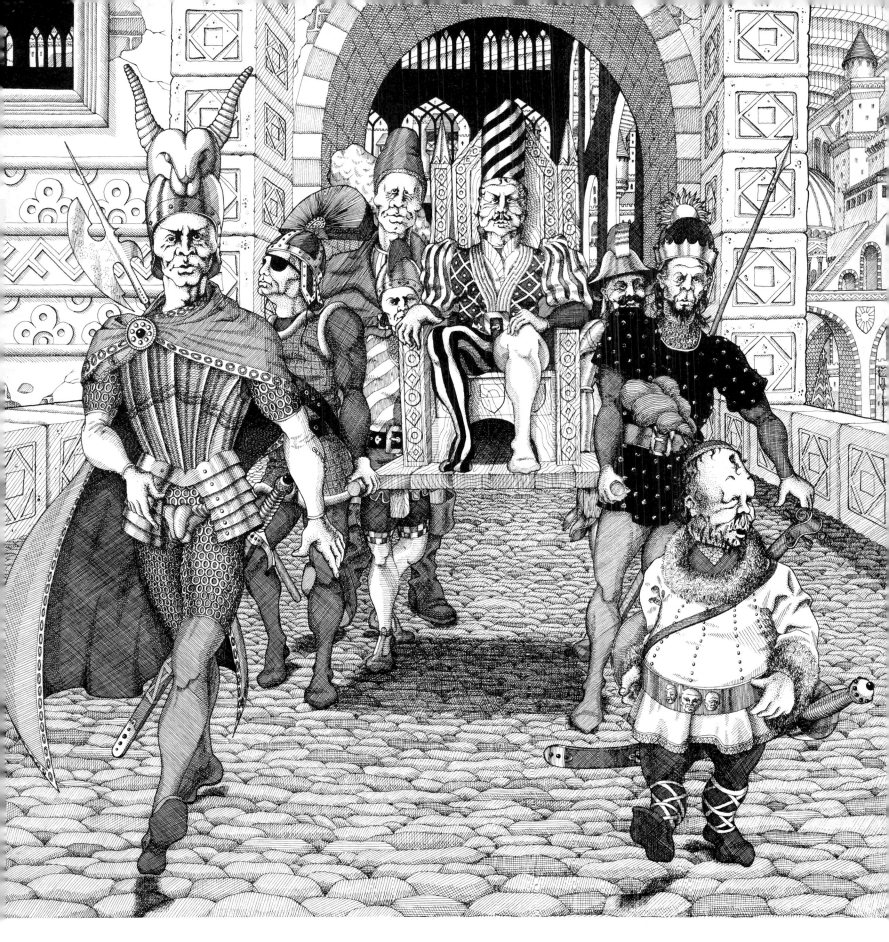

'So be it!' was the lapwing's shrill,
How pleasing to a princely ear —
And yet to one with ears to hear,
How ominous, how boding ill ...

Back home, pleased as Punch,
Crunch, they go, crunch, crunch:
Up the stairs, down the ramp,
Along by many a colonnade,
Crunch, crunch, tramp, tramp —
While all of Pile seems on parade.

Soldiery, pikemen, marchers, archers of the years —
Yeomen sere or insincere or sheer
Young varmints, with their immortality
Bursting with lust and hair from all their ears —
Under their codpieced captains' jurisdiction
March round in drill formation. Such fatality
Of omens makes prediction
For the death of this grey principality.

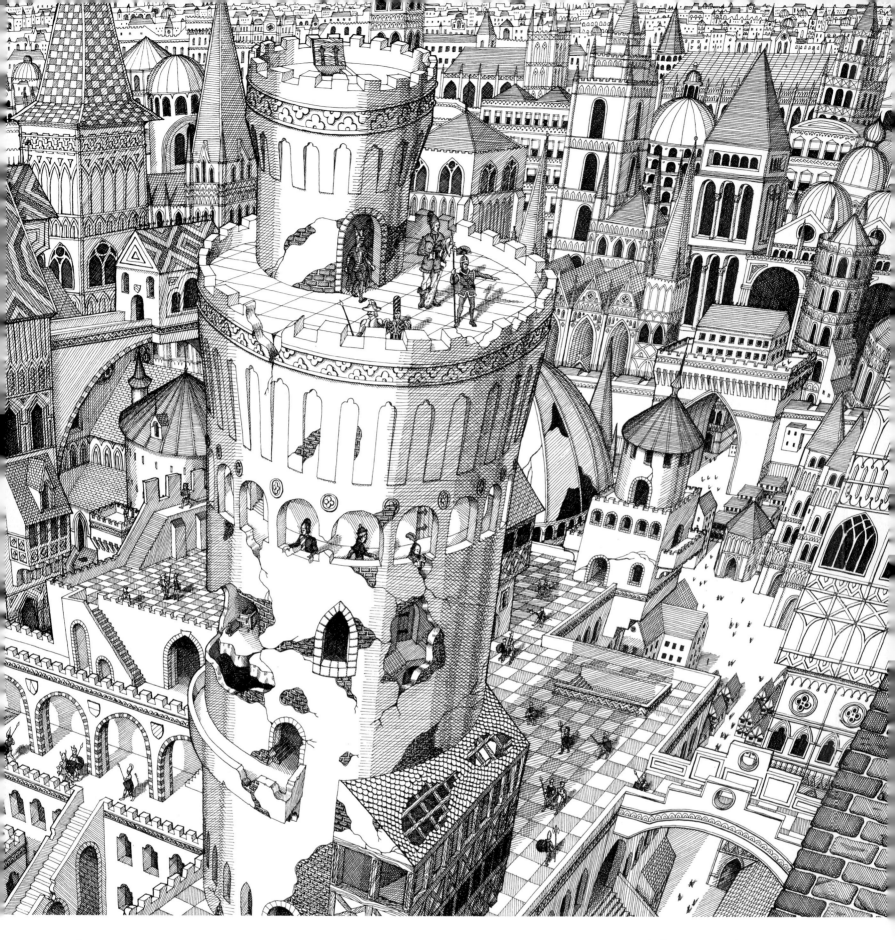

Pale citizen,
So isolate in icey light,
He gazes down on lonely pageantry
Or dies of pike-wounds in a peristyle.
The system breaks him like a tile.
So much magnificence in malachite!
Such sterling stuff in stark sepulchral stone!
 — That all this immemorial masonry
Burdens his spirit till his clay's restored,
Battered by fruitlessness and routeless rage,
To some lapidiary tomb. Alone,
Each unit's regimented yet still sole:
So caged, the bars are in his brain,
So barred, his brain is but a cage.

Rogues, saints, virgins, or floosies,
Each walks a path upon his broken soul
Among all the monuments. He chooses
His shattered frail course, a lane
Of scattered pale porcelain.
And perhaps has a feeling
Hard to deny
Some towers are peeling,
Some structures may die ...

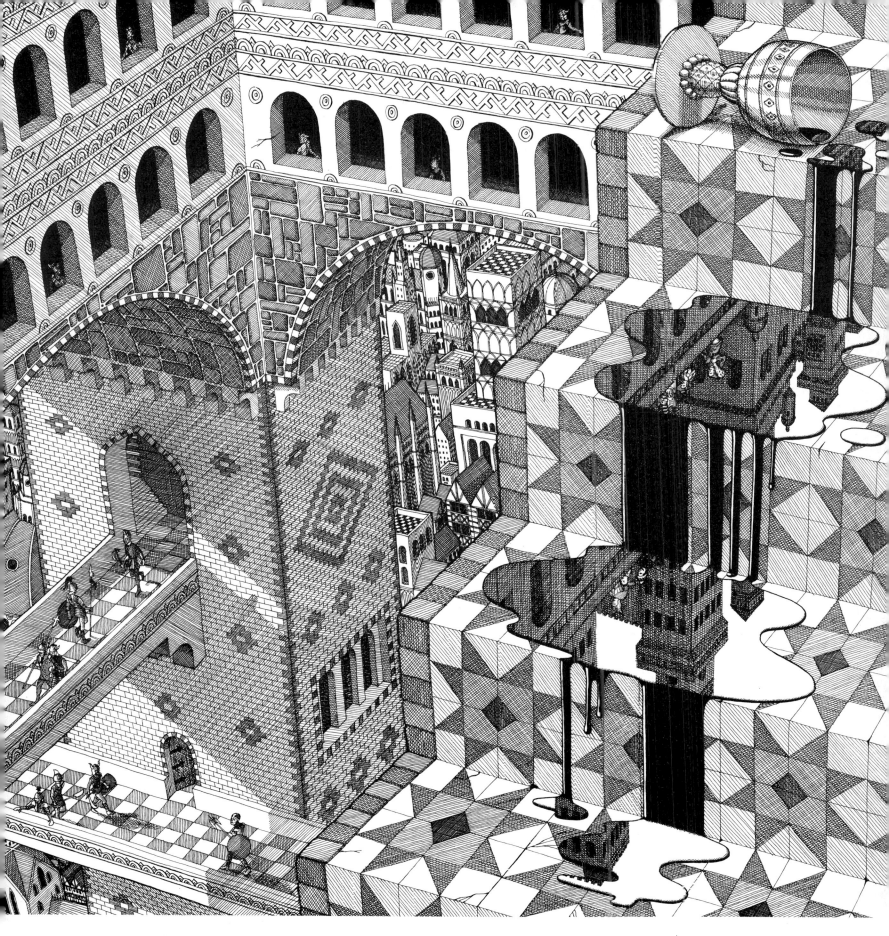

But doom is nothing to the grape
And heavy wine can hebetate
The pain of conscience. Opiate
Was sought and bought to court the Court
In various form and various shape,
In every colour, every taste,
From every corner of Creation,
Himalaya, valley, waste:
Dalmatia's nations, Asia's geishas,
Caucasian clumbers, Cumbria's capons,
Camphire, calypsos, and Constantinopolitan orations:

Plus dancers — all sensational Alsatians —
Magic Malacia's importations,
Luce, and lutes, and lucubrations,
Oysters, roysters, flagellations,
Harlots of reassuring potence,
Oceans of Boeotian potions.

Meanwhile, St Klaed worked out its quotients.

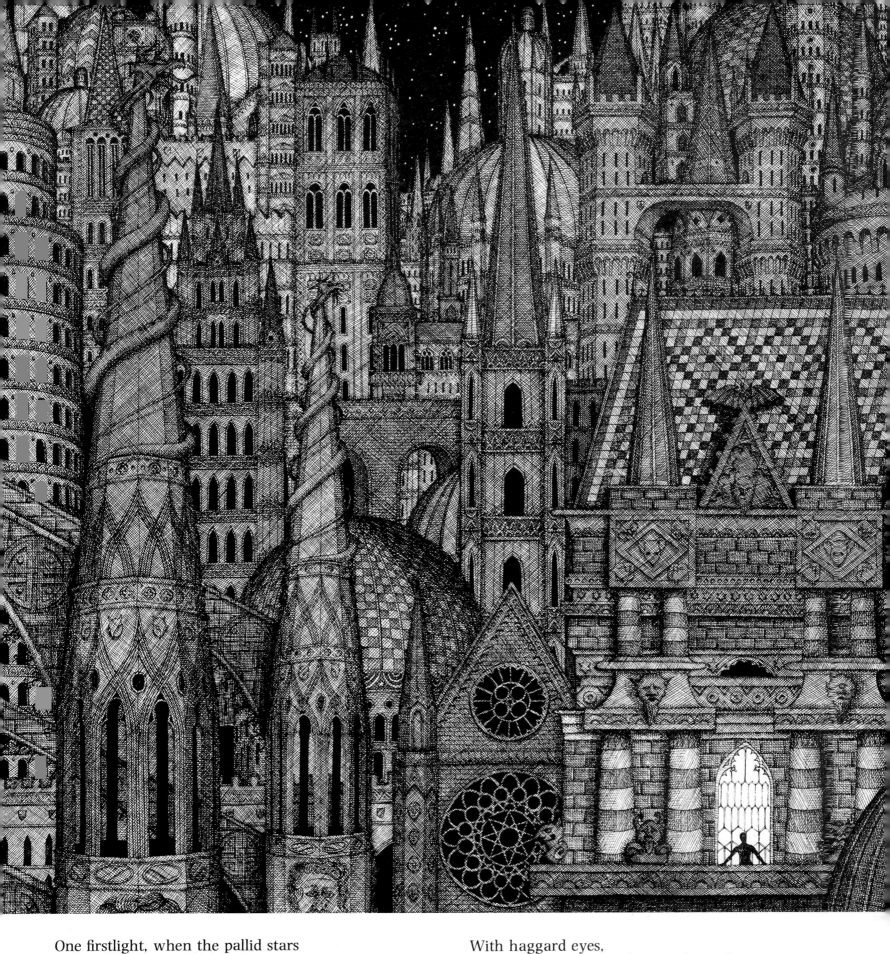

One firstlight, when the pallid stars
Still laced their parallelograms
Through palace window-bars, from sleep
Up starts the great Prince Scart and mars
The silence with his cry.
 'Grand-dams
Of lovers' lues! How my dreams conspire
To trample peace deep, deep in miry sty!
What dooms do dance within my forehead's bands!
Sanity gives!
Klaed, let my foes in truth come charging nigh
If my curse lives.
Blessed saint, or my endurance stands
Or I in durance lie!'

With haggard eyes,
He glares between the bars at dawn-deep squares
Deserted yet. The citizenry lies
In bed, or love, or sleep, or even prayers,
Snug still among the mortared urban layers,
Their fates another's enterprise.

Yes, they,
Liegemen and thews,
Awaking when the sun's first ray
Subtends a tangent on the day,
Know well that Pile from spire to mews
Has freed them all from Nature's thrall, from green,
 from trees!

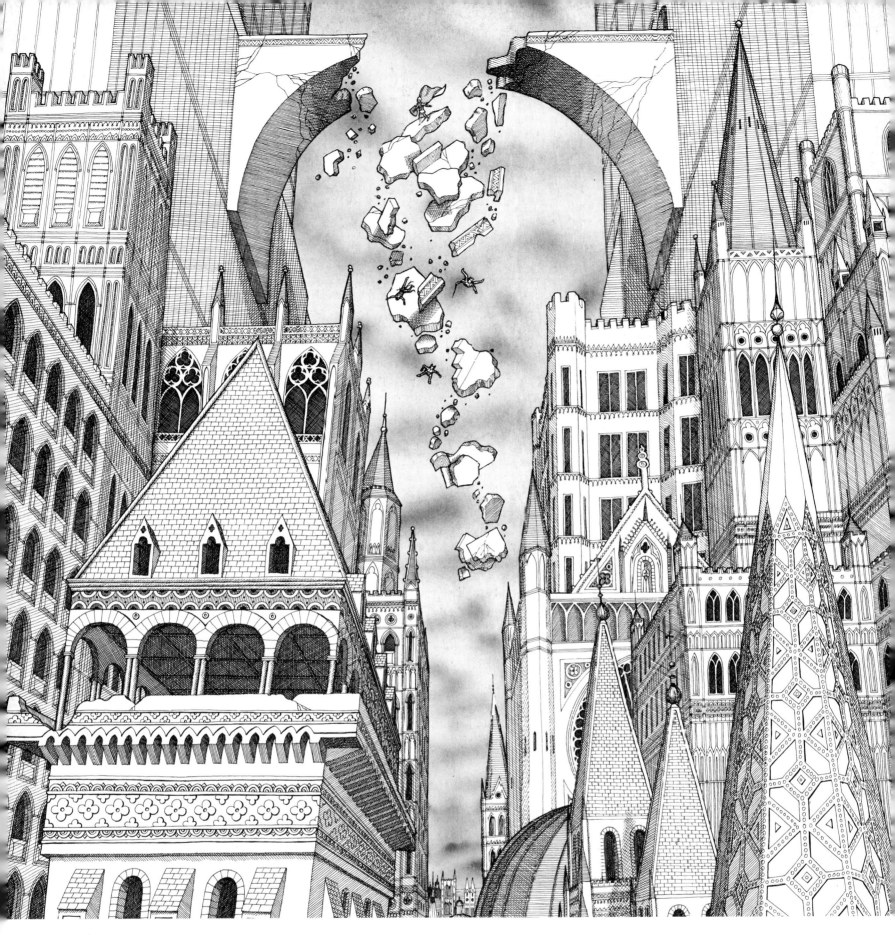

Pythagoras
Has abolished grass.
They're Men! As Men, the Eternal Geometries
Remind them of their great (if weary) state;
Each dawn renewal is
Of this hypothesis.

The Palace fights improper superstitions
By standing for some proper propositions:
Each tower by pre-arrangement's bid
To praise the toilings of Euclid;
By morning star, each turret great,
Each garret, each high pot, is news
Of truth on the hypotenuse,
Each attic's

Dedicated to mathematics,
Tries to replicate
A theorem. Not a dome is random;
Even a quad *est demonstrandum*.
All this by half-past eight.
Troops form in line
Abreast by nine.

By half-past nine, it is too late.
Clocks strike, Klaed strikes.
Q.E.D. Suddenly
The gnomon shrikes. The foemen's pikes
Glitter briefly, downward falling.
Ancient walling shares their fate.
Pile starts to disintegrate.

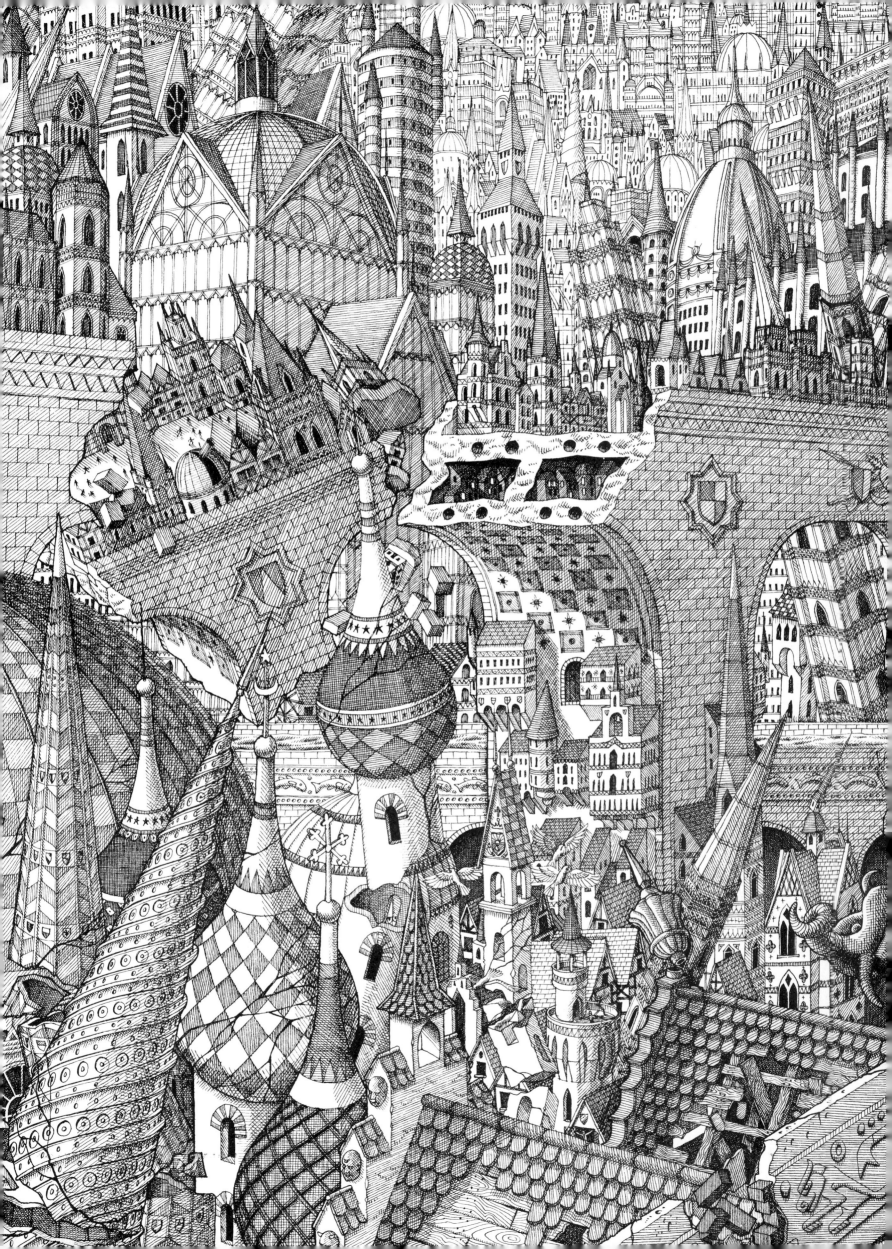

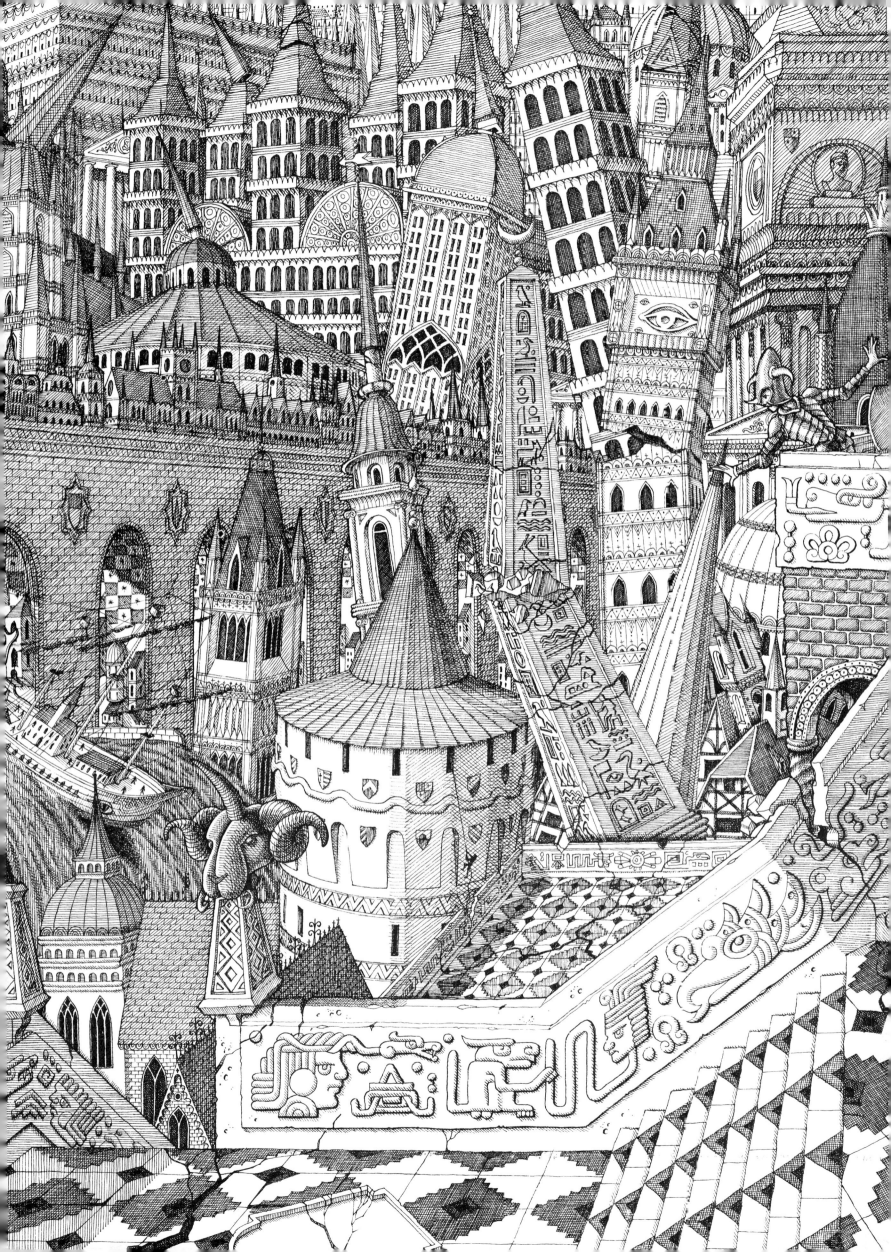

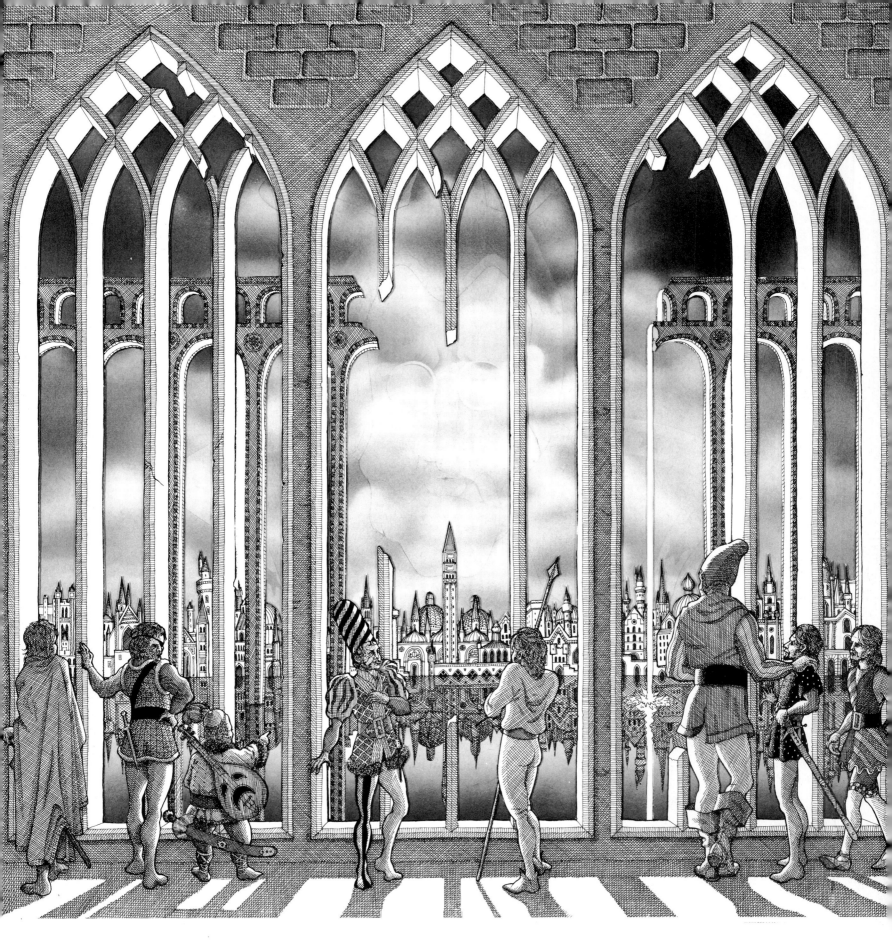

Tower after tower begins to topple,
Wobble, fall to flag and cobble,
Interring noble foes in rubble.
Far worse, the aqueducts, when next dawn breaks,
All over-spill. The subterranean cisterns
Rise like revolutionary lakes,
Canals throw off their gates and pistons.
Drains become streams and alleys torrents,
Courtyards ponds and streets swift rivers,
Pedestrians swimmers (with abhorrence).
Stairways are waterfalls. Each building shivers.
Then night. Silence descends. It ends.
The Grand Square is a plumbless waveless sea.

To Scart, more terrible than moon appears
A spectral sky-born visage. Thus it speaks:
'God and Computer, I. For man's correction
Has your watertight world sprung these leaks.
Between you and the Elements you place
This great necropolis. Alas, perfection!
You mortal men are only elements
Combining briefly in a form of sense,
Mere chimerae of truth — as this projection
Is just illusion dressed in Blessed Klaed's face.'

Cried Scart, 'But —' 'Cease you, Scart, your world
　　　grows wet:
You sink, you drown. You must sink deeper yet.'

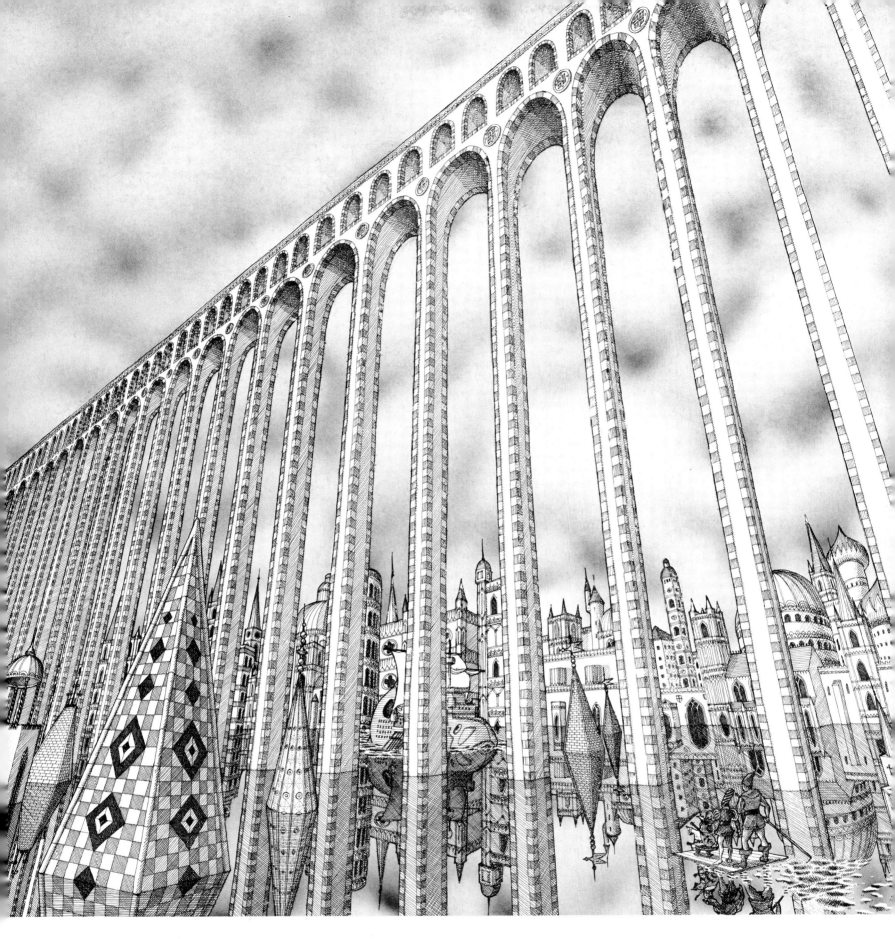

This curse no distant echo could withhold,
Which shrilled along the surface of the flood.
Silence and gods alone have such a tongue
For such affliction.
The malediction reigned upon the marble
And quelled it. In the lapidescent waters,
A new ulterior Pile shone forth and clung
Like barnacles beneath the reflected old,
So perfect that a man must pause to choose
Real or pretence, which one to win or lose.
Stillness hung above this tempting error
With ever-watchful terror, like a mirror.

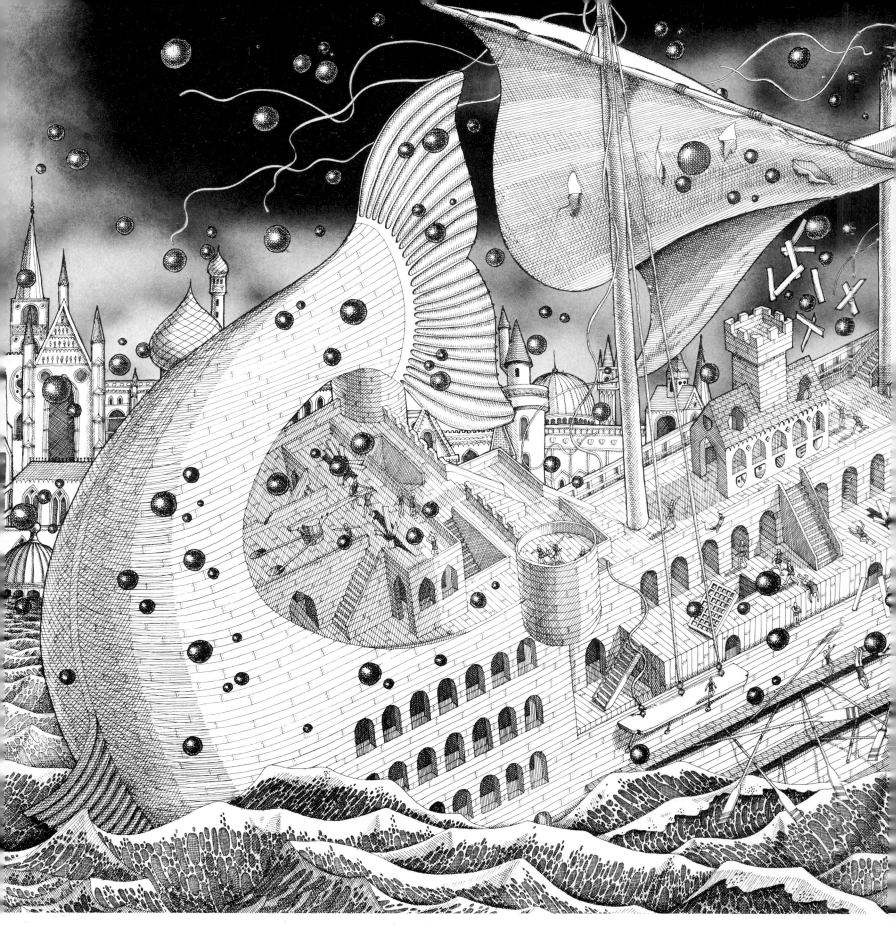

Through that glazed stillness, Scart crept forth
Without farewell to friend or lady,
Took only two henchmen shady,
Took to water, compass set due North.

When hardly launched upon the maze
Of floating tower and sunken bower,
They met a boat of sullen power —
A whale, a wooden whale of waterways.

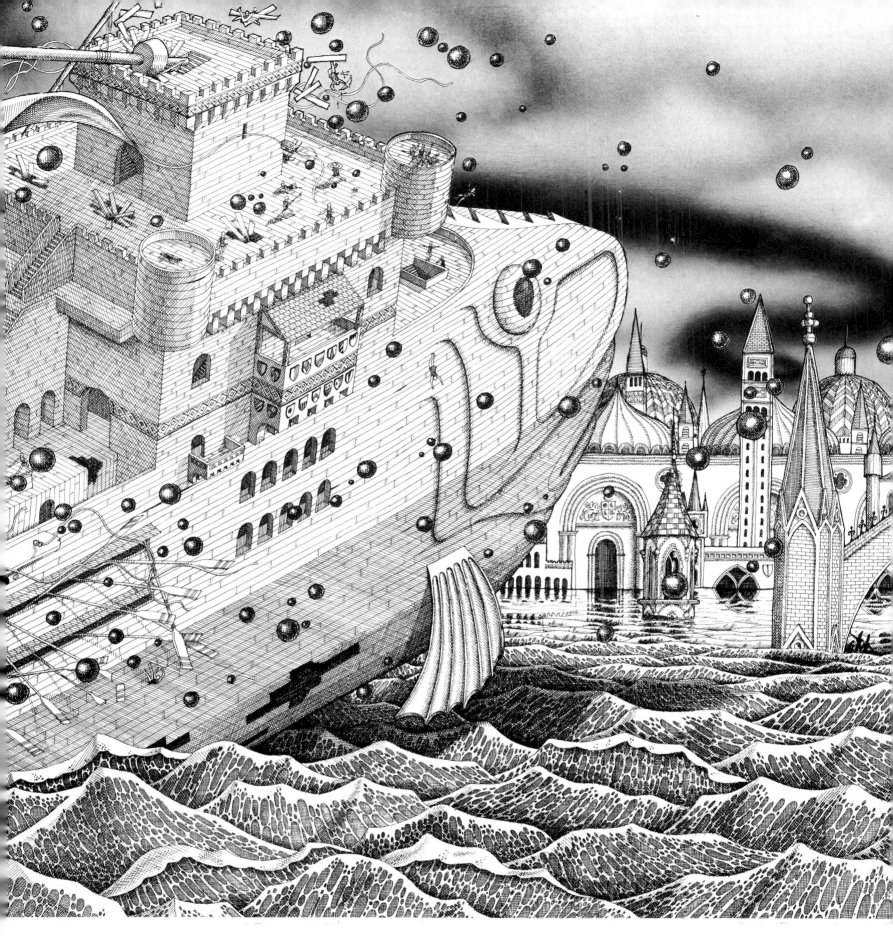

It gulped them as it forward surged
Down timbered maw, and then — God's graves! —
Turned turtle, dived beneath the waves,
And in the ulterior Water-world emerged.

What strange horizons were submerged
In inside-outness! Sense's slaves
Die where the doppelgänger raves,
While sense itself, mirrored, is double-dirged.

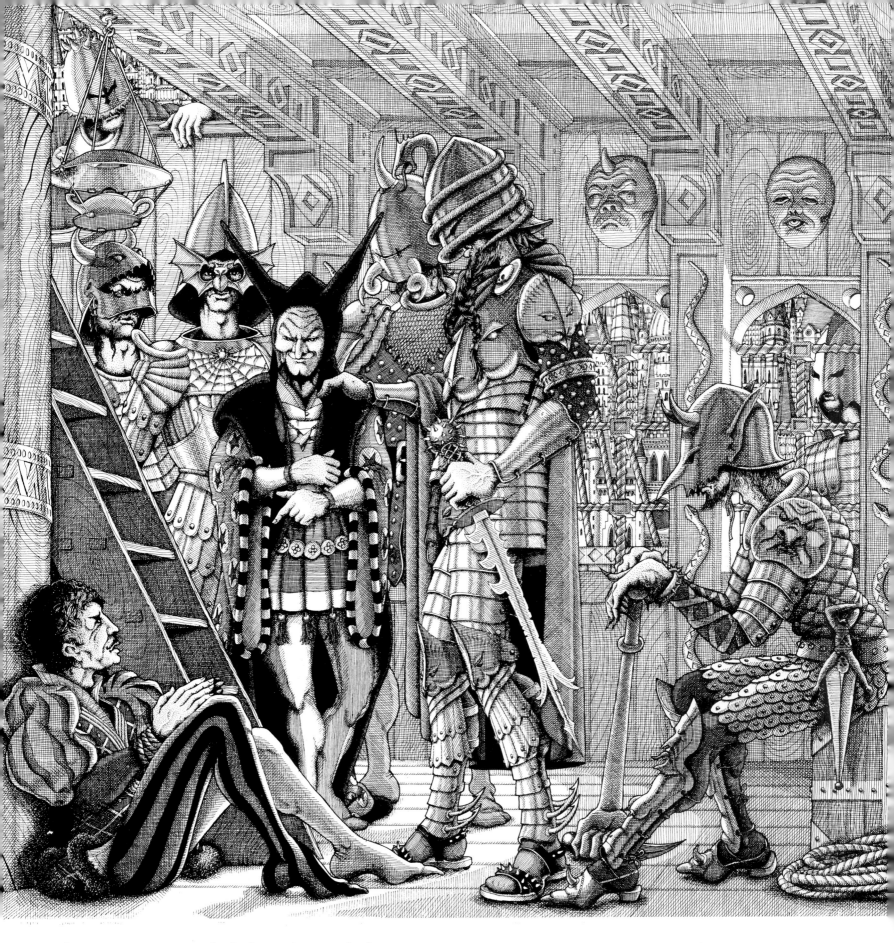

Their greaves were spiked, their visors tusked,
Their tassets, skirts, and breastplates horned,
Their helmets and their arms grotesque —
Their whole ship was an arabesque —
These strange ulterior men, adorned
With plaited beard, and thickly musked.

Once they had bound Prince Scart with chains
And cruel ropes, their leader came,
A man of habit odd. With grave
Gesture, he to his captive gave
A casket which contained the Name
Of Him who ruled these deep domains.

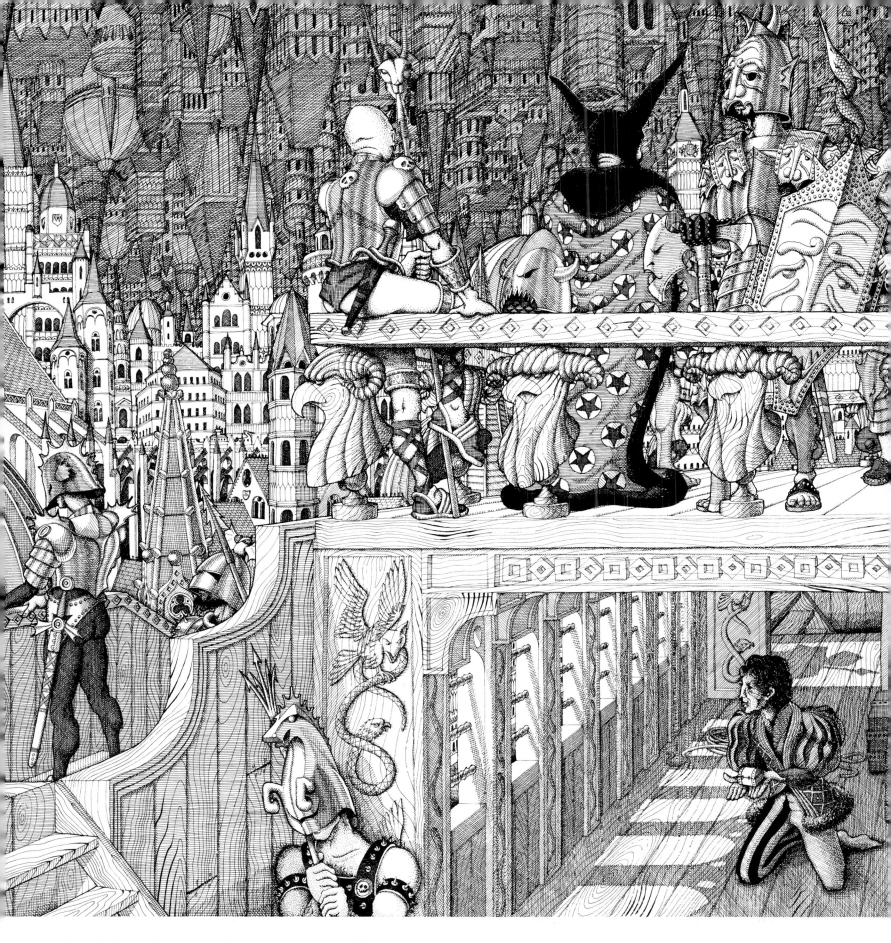

Scart's thoughts are vultures swooping swift
Upon the carrion of his crime.
Not by his strength but lack of it
He caused the schism. He must sit
Bound in the bondages of time
And impotent to heal the rift.

A league, a league! The captain's roaring,
Sailors scamper, sails are furled.
Their destination lies ahead.
Prince Scart hears 'Elip! Elip!' said —
The name of this ulterior world —
As wooden whale pulls in to mooring.

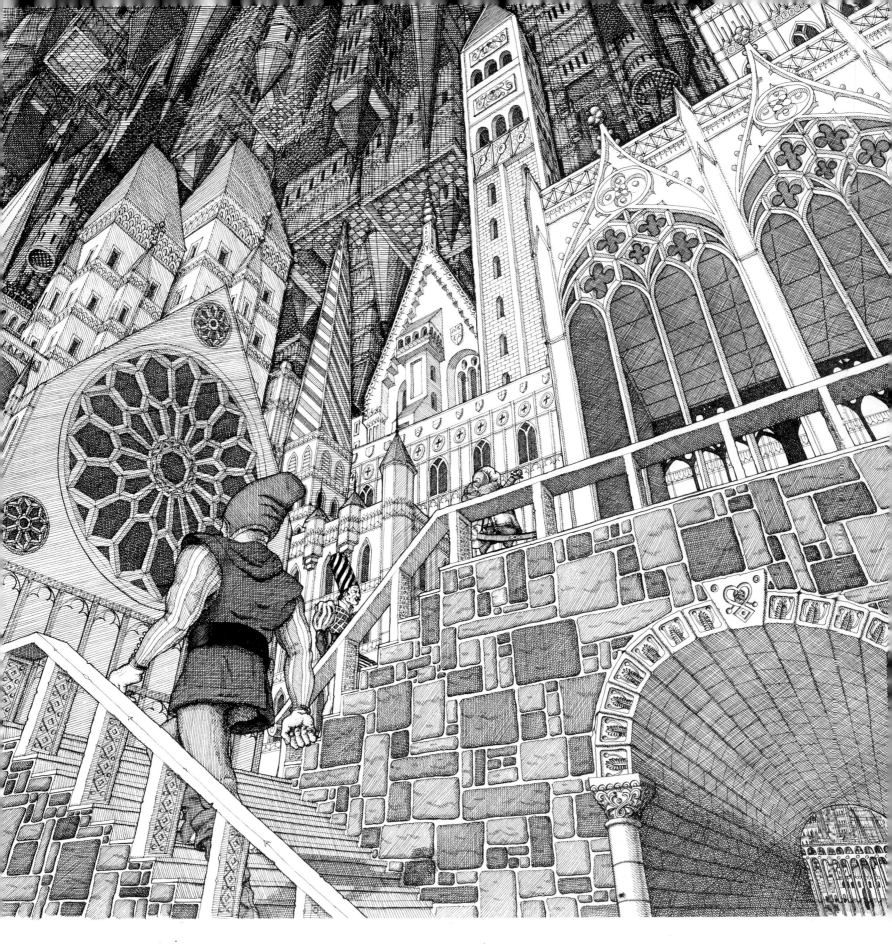

By mirror-logic, as they land, Lord Scart
With Dwarf and Torturer are free to go,
Since they were free to come when setting out.
Submerged they climb, whilst looking all about
At Elip. Elip mirrors Pile although
Religious science snipped the two apart.

So much magnificence in malachite!
Such sterling stuff in stark sepulchral stone!
That Elip is, a twin to brooding Pile;
Elip's computer saint is found, meanwhile,
The chest declares, to be Dealk the Known,
The trio moves to meet that ancient wight.

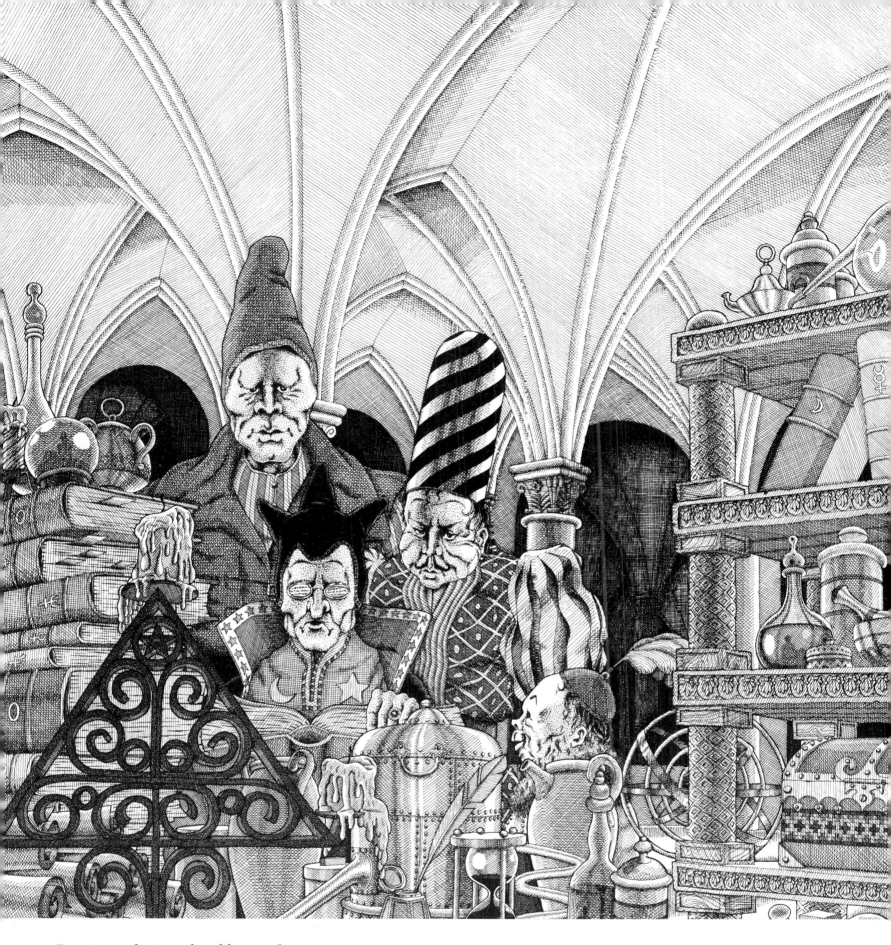

By mirrored circumbendibus and ways,
Half-terrified by phonocamptic booms,
They find Dealk and utter humble praise.
Behind the walls of sodden halls and rooms,
Dealk's Computer eloquently looms,
Cross switching to a mass-illusion phase.
Before them stands, with eyes of glowing pewter,
A simulacrum of the blessed old saint,
That fructifying, death-applying, ever-trying,
　　　law-supplying, scarifying, atom-frying, eagle-eyeing,
　　　stultifying, secret-prying, edifying,
Petrifying,
Dealk's Computer,
Conscienceless and quaint.

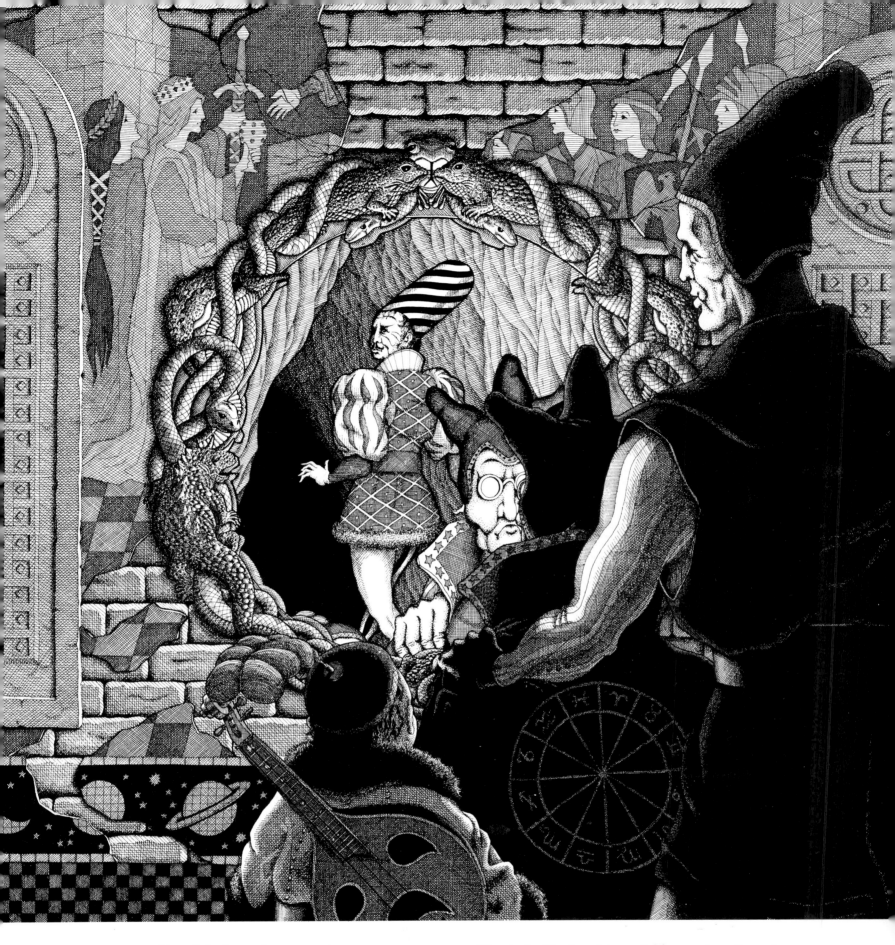

'Great Doge of Dealk's deep dynamics,'
Scart utters in miniscule cry,
'Lord of Illusion, Cosmos, and Ceramics —'
A multitudinous Something doth unravel
From far foundations, bowels, and navel
Its contemplation thus to make reply:
'Cease, Princeling,' as the gull mewls in the sky.
'Cease flattery. The greybeard who your vision
Favours is a code for vortices
Of Matter, Mind, Direction, and Decision
Forged out of fission and of fusion. These
Are Nouns which move in grand declensions
About the grammar of the constellations
In proper gravity; through such dimensions,
Both Space and Maestro Time are Verbs

The twin Verbs of transfinite conjugations.'
To this there seemed no answer. Then the gull
Cried, 'I know all — it's only Will I lack.
You have Will, Human.' 'Sire, I would go back
To where I was before ... ' Scart's tone was dull
From lack of hope. 'I've changed, Sire, I can see
The great disaster's my responsibility ... '
He spoke. Straightway, Dealk caused to unroll
From solid matter there, outrageously,
A Womb, a Gateway, Orifice, or else Black Hole.

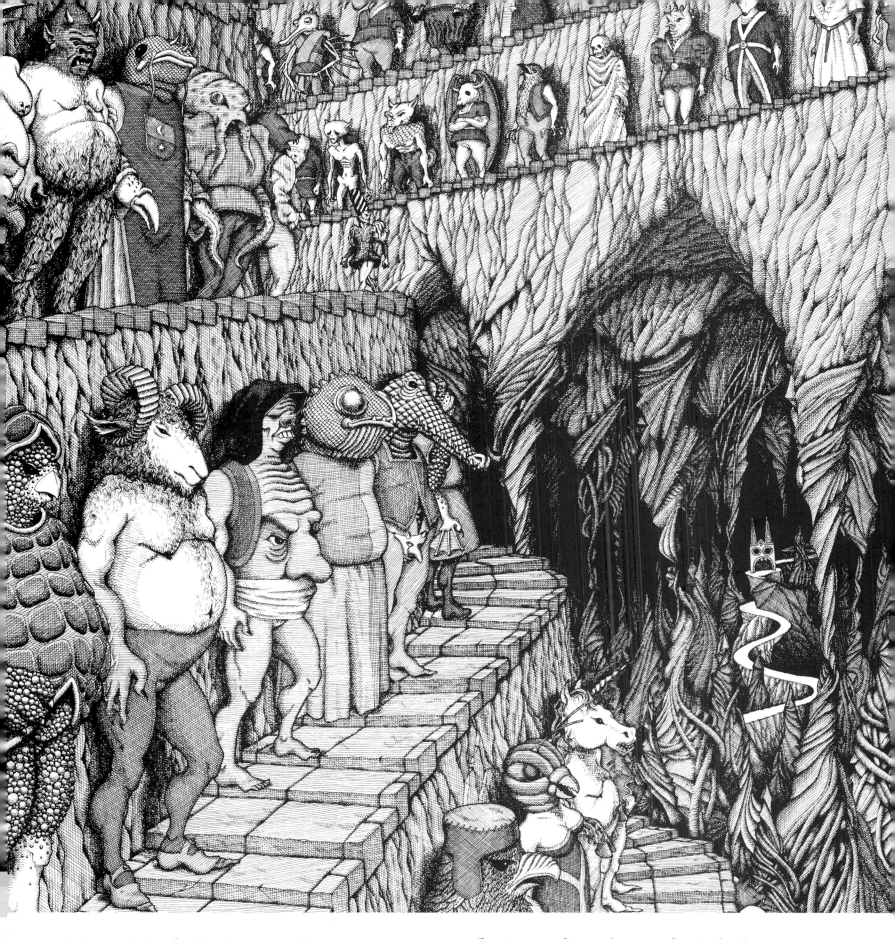

'Advance!' shrieks the Computer. 'Go,
For you have in your thought advanced
To manhood proper by this show
Of due responsibility;
Besides, your innocence is much enhanced
Considering the context of your guilt,
As birch and fir grow sparse and stuntedly
Northwards, towards the tundra. Age like silt
Had so eroded Pile, one shouted word
Brought on its dissolution. Now you'll be
Migratory as catapulted bird
Which claims all continents as springtime's due —
Advance! Begin anew in Primal Time!
All spatial structure bends its bow for you;
See how the world was, ere Man's clocks began to chime.'

Scart stepped into the tunnels of rebirth,
Whereon the Gateway melted closed behind,
Relinquishing familiar ties of Earth,
Yet greeting Unknowns near to former mind.

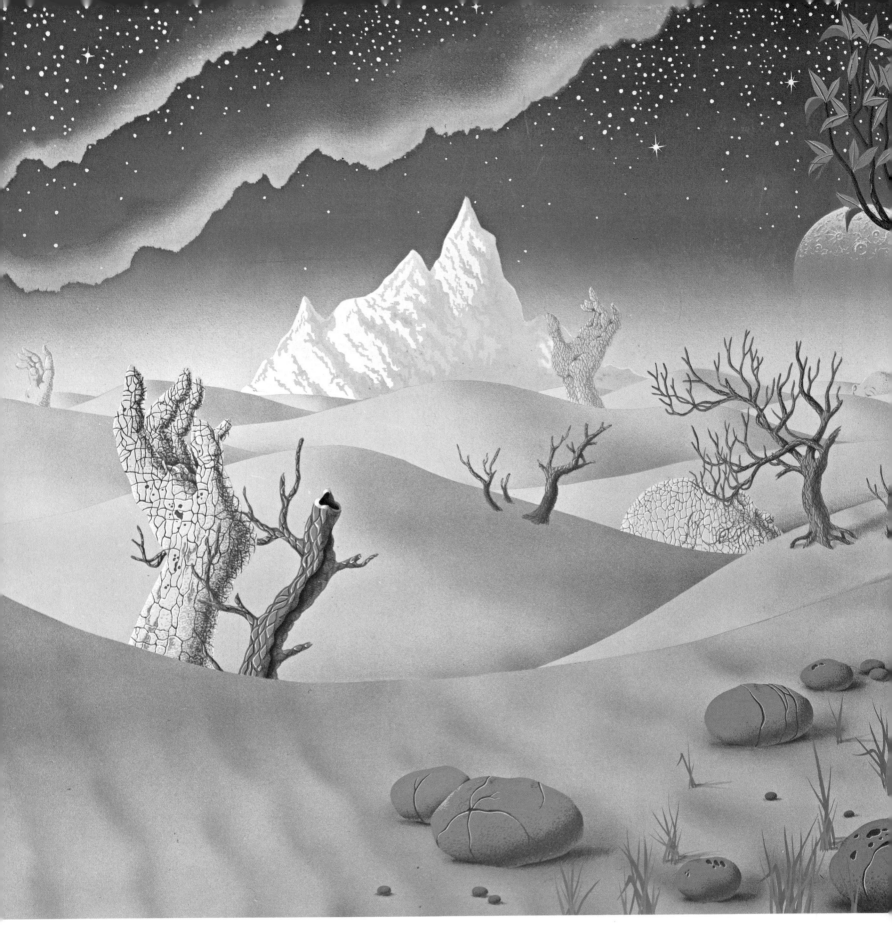

Through Chaos and the vast Unformed,
Ere DNB had learned its ABCs,
Scart entered on a world transformed,
The Primal World. No sign he sees
Of Dealk's two grand Verbs: vocabulary's
Here more demotic, more erotic.

He takes a walk
Before coccoliths laid the chalk,
His flesh and bones
Amid the enemies of stones —
Where things of sap
And blood and scarlet feather tap
The soil. Home
Was limited to monochrome:

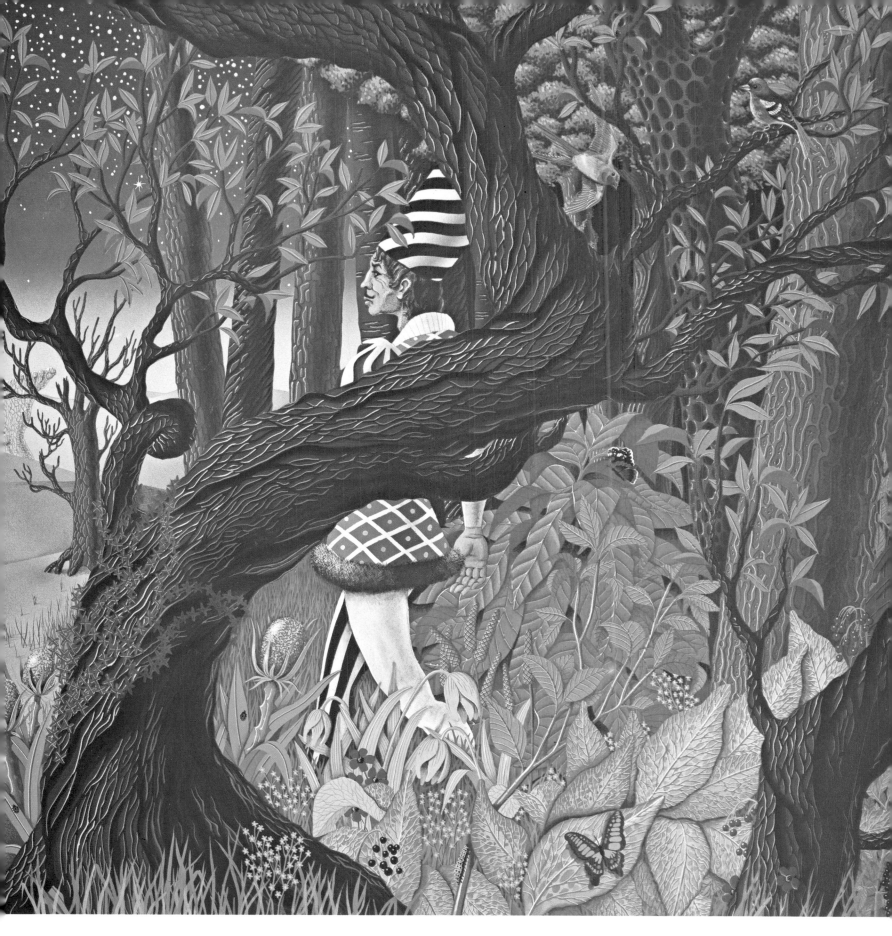

Abroad, the smell
And colour take him in a spell.
Forward he's drawn.
Each step, the desert turns to lawn,
The sky to shoals
Of stars, as Creation unrolls.
Only his early
Self dies, ossified and pearly.

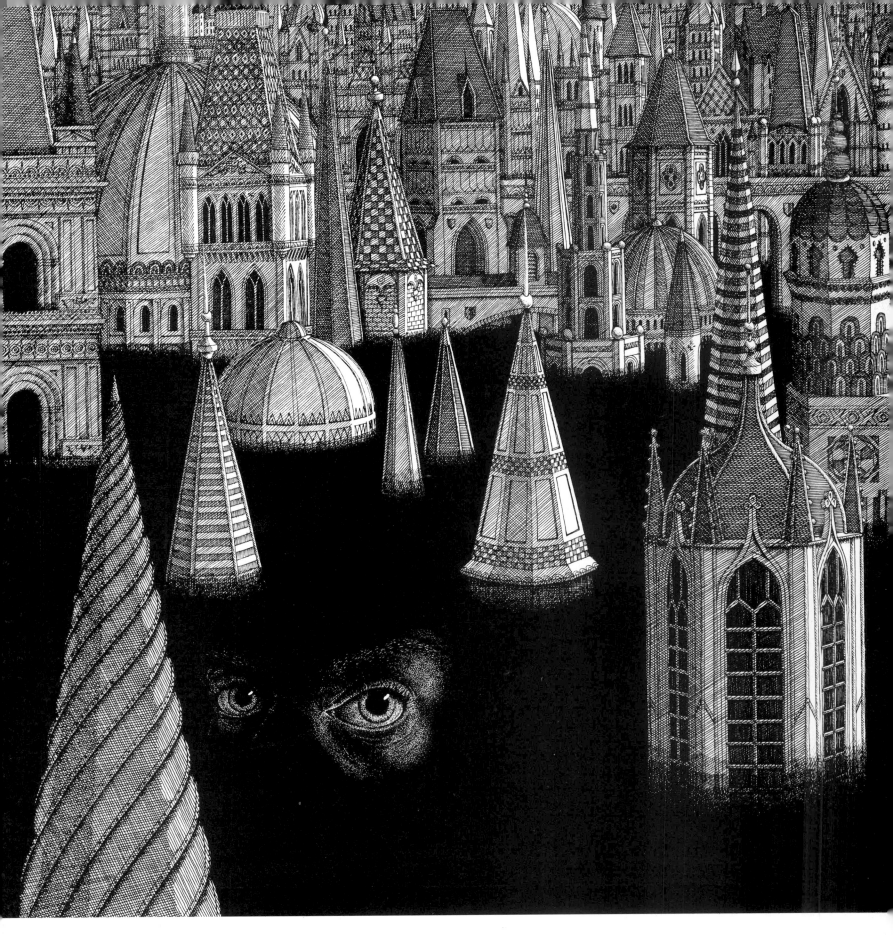

Thus one more psyche to the bright world came.
There is a price for such expense of force
Needed to launch the Scart bird from its cage,
To give his unaimed soul a flight and name:
Paternal Dealk sank back to its source,
Maternal Elip/Pile went to that Dark
Unfolding wraithlike from the depths below ...

For every one of us it is the same.
Worlds end or open as we go.

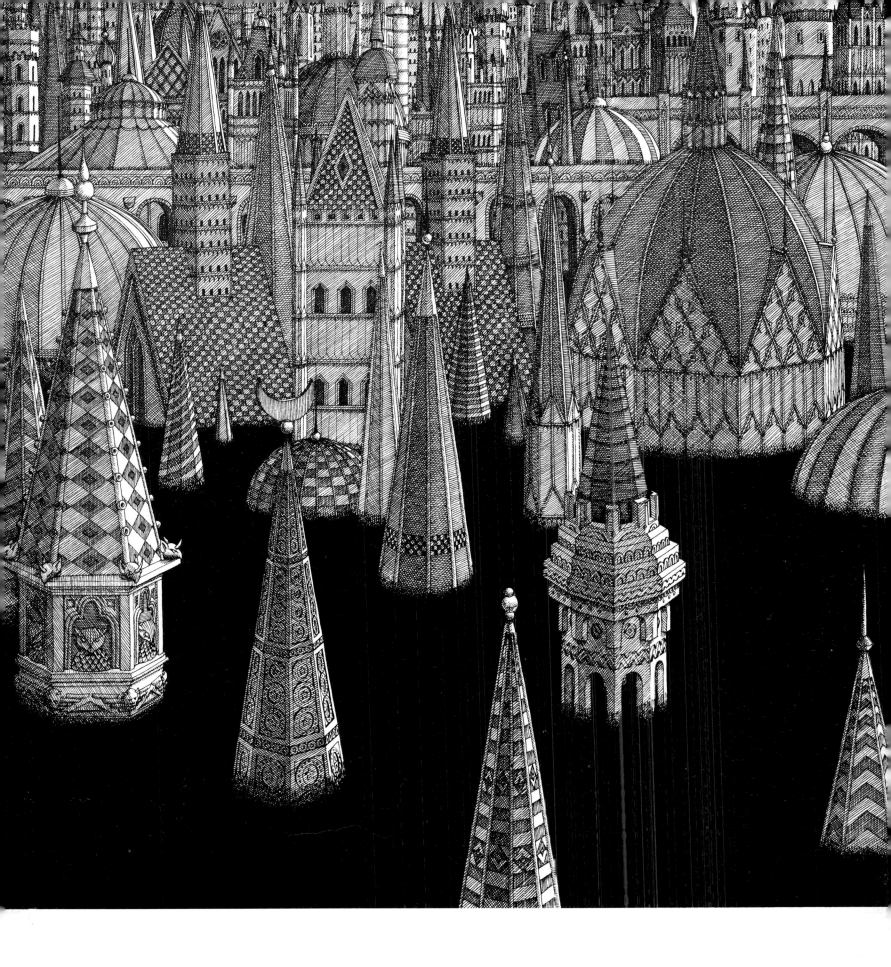

For my mother and father

M.W.

Published in the United States by Holt, Rinehart and
Winston, 383 Madison Avenue, New York, New York 10017.

Published simultaneously in Canada by Holt, Rinehart
and Winston of Canada, Limited.

Library of Congress Catalog Card Number:
79–2260

ISBN: 0–03–053296–5

First American Edition: 1979

Printed in Great Britain
1 3 5 7 9 10 8 6 4 2